YOU WILL LEAVE A TRAIL OF STARS

WORDS OF INSPIRATION FOR BLAZING YOUR OWN PATH

By LISA CONGDON

CHRONICLE BOOKS
SAN FRANCISCO

To my best friend, Jennifer Hewett.
May everyone get to experience a friendship so rife with wisdom,
humor, devotion, trust, and ease. I am so grateful for you.

Library of Congress Cataloging-in-Publication Data:
Names: Congdon, Lisa, author.
Title: You will leave a trail of stars : inspiration for blazing your own
 path / by Lisa Congdon.
Description: San Francisco : Chronicle Books, [2021] |
Identifiers: LCCN 2020028131 | ISBN 9781452180281 (hardcover)
Subjects: LCSH: Self-actualization (Psychology) | Self-realization. |
 Inspiration.
Classification: LCC BF637.S4 C6532 2021 | DDC 158--dc23
LC record available at https://lccn.loc.gov/2020028131
ISBN 978-1-4521-8028-1

Manufactured in China.

Design by Kristen Hewitt.

10 9 8 7 6 5 4 3

Chronicle books and gifts are available at special quantity discounts to
corporations, professional associations, literacy programs, and other
organizations. For details and discount information, please contact our
premiums department at corporatesales@chroniclebooks.com or at
1-800-759-0190.

Chronicle Books LLC
680 Second Street
San Francisco, California 94107
www.chroniclebooks.com

INTRODUCTION

—

Dear Reader,

The book is an accumulation of all of the best,
most important things I've learned in my life.

I hope it will inspire you to live with intention,
connection, curiosity, and joy.

Sincerely,
Lisa Congdon
Artist, writer, and educator

LET'S
MOVE FORWARD
TOGETHER

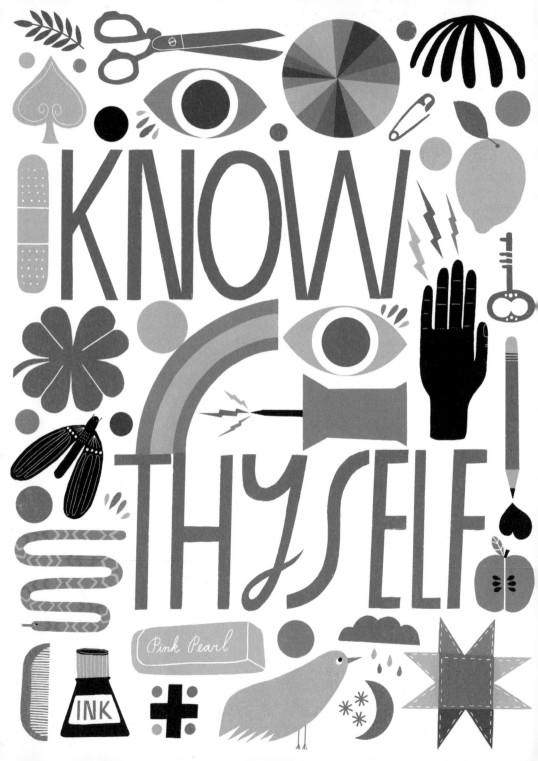

KNOW THYSELF

—

Really knowing yourself is excruciatingly difficult, and it's often painful when you realize what a jerk you can be sometimes! But it's also enormously freeing. You can't evolve if you don't know what you want to change or how you need to grow. Get to know yourself. Be open to feedback from others. Learn to love and honor your deep and complex story. Forgive your past mistakes. Work to grow and change where you know you could be a better friend, partner, human.

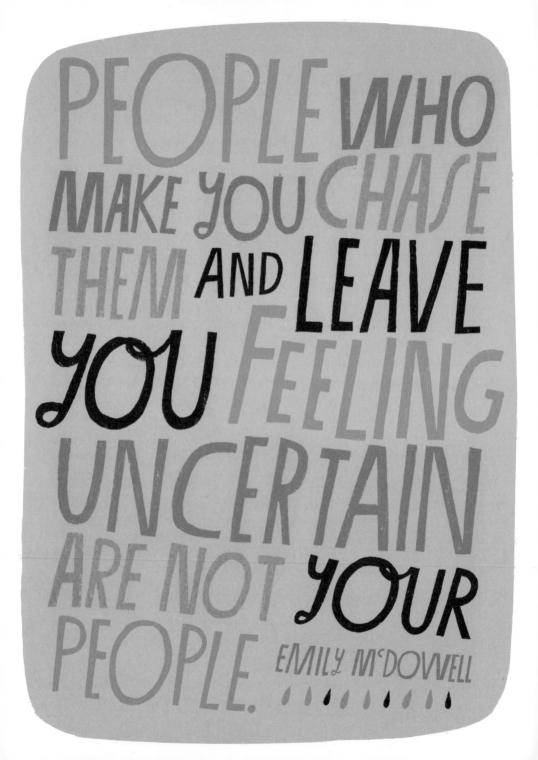

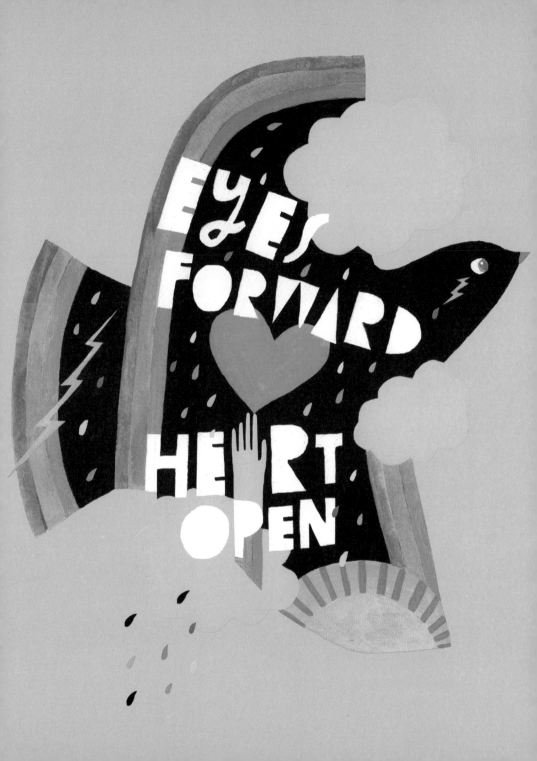

YOU MUST LIVE IN THE PRESENT, LAUNCH YOURSELF ON EVERY WAVE. FIND YOUR ETERNITY IN EACH MOMENT. FOOLS STA OPPORTUNITIES AND LO LAND. THERE IS NO OTH OTHER LIFE BUT THIS.

ND ON THEIR ISLAND OF
OK TOWARD ANOTHER
ER LAND. THERE IS NO

HENRY DAVID THOREAU

EVERY MISTAKE IS PROGRESS

—

How's this for a different perspective: Every time you screw up in your life, you make progress. Mistakes are not a tally of your unworthiness. They actually help us to become better people. On some level we all know this, but we forget it in favor of beating ourselves up or staying in defensiveness or denial. Mistakes and the stuff they stir up are a gift, because they teach us things like setting new boundaries, learning clearer communication, and being kinder, gentler, and more tender and present in the future. Every single human makes mistakes. No one is exempt. When you begin to see mistakes as gifts, forgiveness toward yourself and others happens much more quickly. And when you forgive yourself and use the experience to learn and grow rather than stay stuck in self-loathing or denial, you are far less likely to make the same mistake again. Mistakes are gifts. Use them.

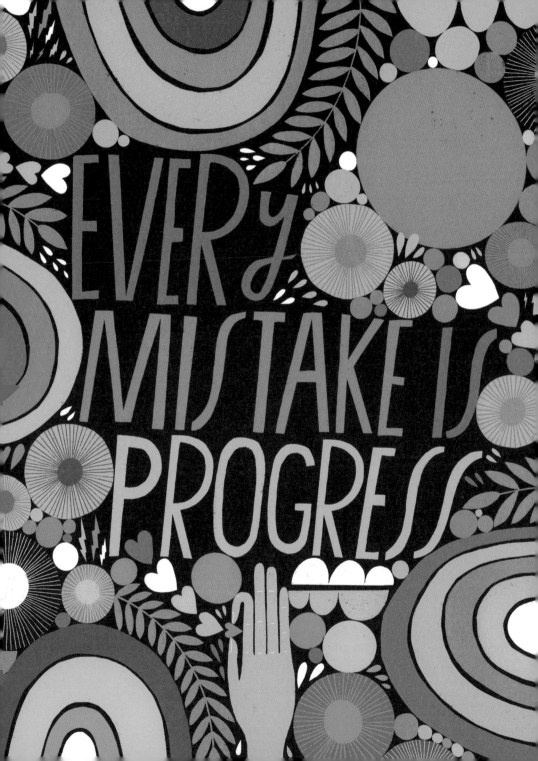

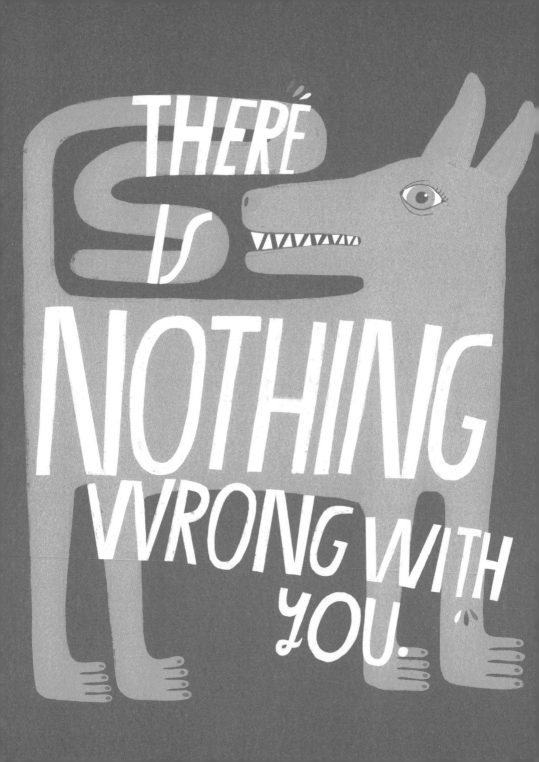

THERE IS NOTHING WRONG WITH YOU

—

Sure, we are all damaged and fallible. Being a human is hard. And
we are all harboring pain we need to work through. But no matter
what mistakes you've made in the past, and no matter what anyone
may have told you, there is nothing wrong with you that makes you
unworthy of connection, love, and belonging. Understanding this is
your path to self-love, and self-love is the path to healing.

WHEN YOU CAN'T FIND SOMEONE TO FOLLOW, YOU HAVE TO FIND A WAY TO LEAD BY EXAMPLE.

ROXANE GAY

EMBRACE THE SUCK

—

When we openly embrace the difficult and challenging circum-
stances in our lives, our internal struggle transforms into learning,
which means we are able to work through the pain more swiftly
and also get something out of the experience. Embracing the
suck requires curiosity over judgment, learning over resentment,
and humor over taking ourselves too seriously. Once in a while
we might even be grateful for a painful experience, because we
learned so much from it or it led to a positive outcome.

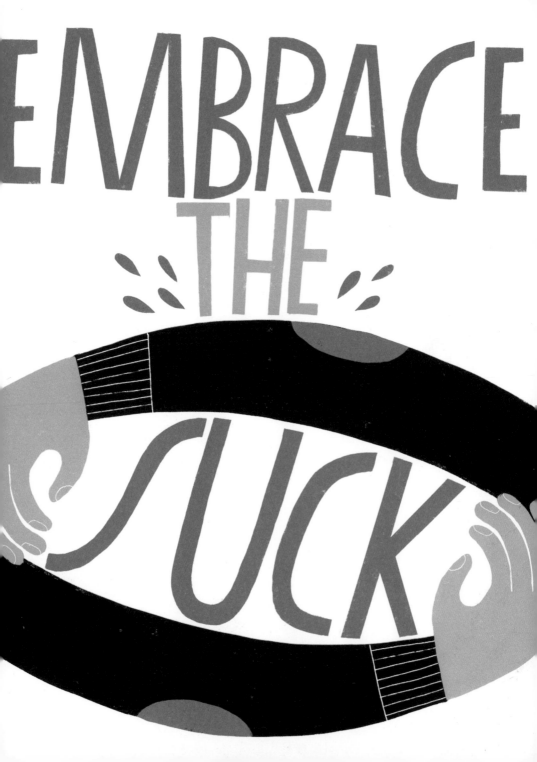

NOTES TO SELF

1. YOU CANNOT & WILL NOT PLEASE EVERYONE. THAT IS A FACT OF LIFE.

2. BY TAKING CARE OF YOUR OWN NEEDS, YOU WILL SOMETIMES DISAPPOINT OR EVEN ANGER OTHER PEOPLE.

3. HOW OTHER PEOPLE REACT TO YOUR CHOICES IS NOT YOUR RESPONSIBILITY.

4. THE GREATEST RESPONSIBILITY YOU HAVE IS TO YOUR OWN WELL-BEING & HAPPINESS.

NOTES TO SELF

—

We are often conditioned to believe the opposite of these four facts. Most of us grow into adulthood believing deeply that other people's needs are more important than our own and that we should always work toward pleasing others and fixing other people's problems. And often we feel like a failure when we can't succeed at that, which makes it a vicious cycle, because it simply isn't possible all the time. Abiding by these truths makes you a better, more present friend, partner, parent, boss, client, employee — not a worse one. Honoring and being direct about your own needs helps you to stay out of resentment and stress and in presence and truth with yourself and others. All of this can be enacted with love, respect, and kindness.

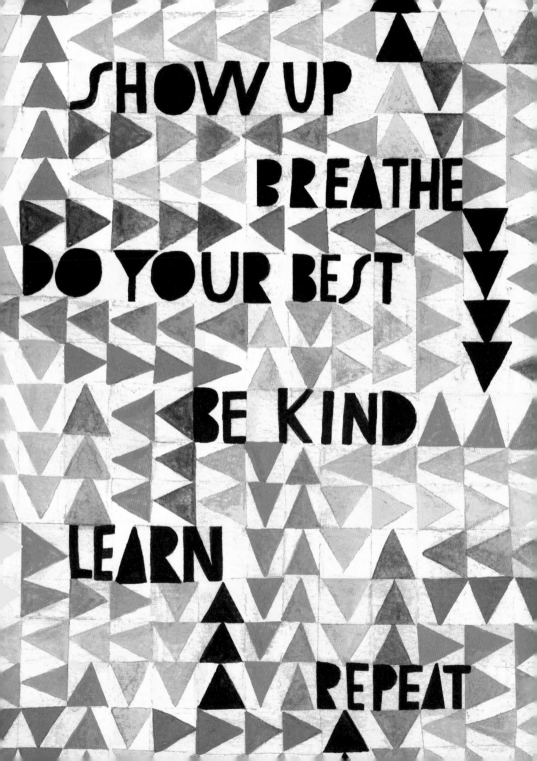

LOVE, BELONGING, AND CONNECTION

—

Love, belonging, and connection are three of the most important sources of well-being. Every single person on this planet — even those of you who feel like you have made too many mistakes or hold buckets of shame about your past — is worthy of love, belonging, and connection. Even your worst enemy is worthy of love, belonging, and connection. The more love, belonging, and connection we offer to others, the more we are able to experience those sources of well-being ourselves.

LOVE

BELONGING

CONNECTION

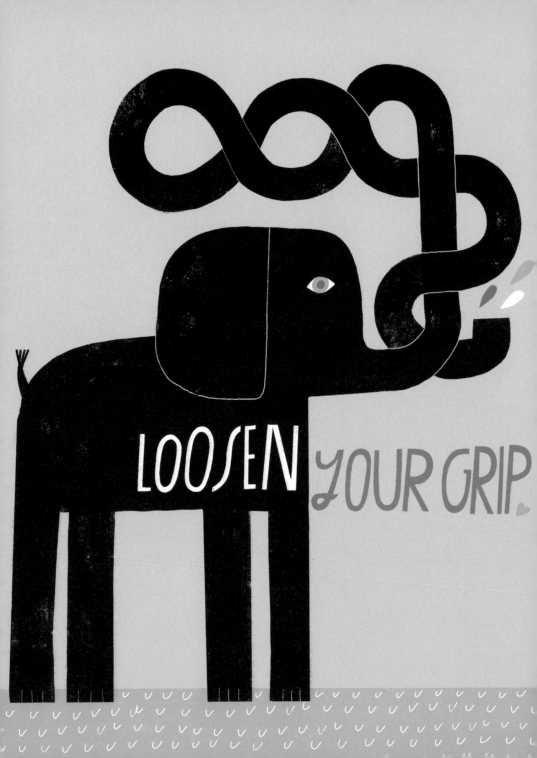

LOOSEN YOUR GRIP

—

Do you ever catch yourself getting lost in your thoughts, holding your breath, tensing your shoulders, or obsessing over this thing or that? Do you fight internally to control every little thing in your day? Do you take things so seriously that you find yourself having obsessive thoughts, only to realize later that worry was a waste of energy? Continually reminding ourselves to loosen our grip helps us to relax. It's amazing how something as simple as reminding yourself to not be so serious can be so helpful.

LIFE IS A SERIES AND SPON CHANGES. DON'T THAT ONLY CREATES SORROW. LET THINGS FL FORWARD IN

OF NATURAL
TANEOUS
RESIST THEM;
LET REALITY BE REALITY.
OW NATURALLY
WHATEVER WAY
THEY LIKE. LAO TZU

IT'S OKAY NOT TO KNOW

—

Do you ever find yourself wanting to BS your way through a conversation, an interview, a date with a friend, or a family argument at the dinner table? Do you ever feel a sense of shame because you don't know something you think you should? The good news is, there is no shame in not knowing — whether it's not knowing certain facts, not knowing where your life is headed next, or not knowing exactly where you stand on an issue. Admitting that you actually don't have the answer or haven't heard of the thing under discussion is actually incredibly liberating. Speaking your truth — as difficult as that can feel around others — keeps you in alignment with your true self.

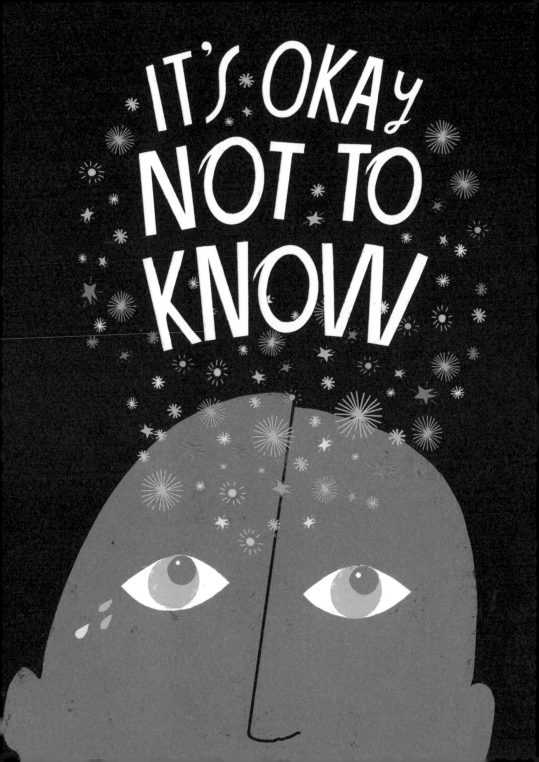

COMMUNITY OVER COMPETITION

—

Many of us were raised to believe that there is only so much to go around, that if you have something, it means that I can't have it too. Therefore, we must always be in competition with others. But in reality, you having something (a skill or talent, an opportunity, a success) doesn't mean that others can't have something similar. When we begin to see that there is enough for everyone, it means we can support one another openly, refrain from jealous gossip, celebrate everyone's successes and important life events, and build a stronger, kinder, more responsive community.

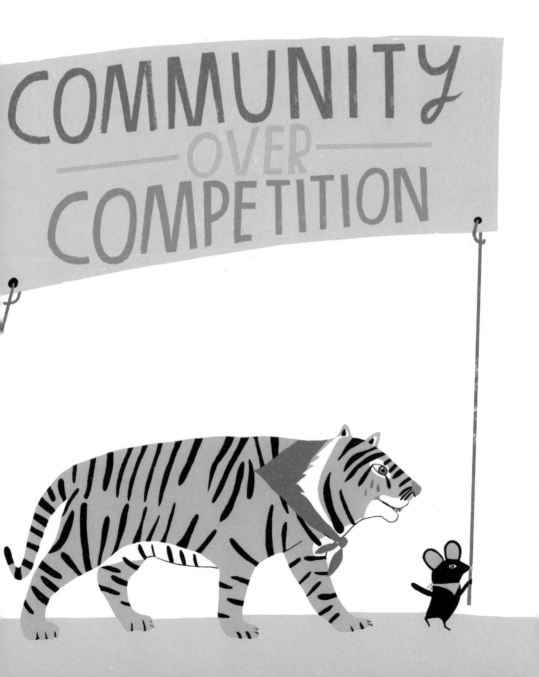

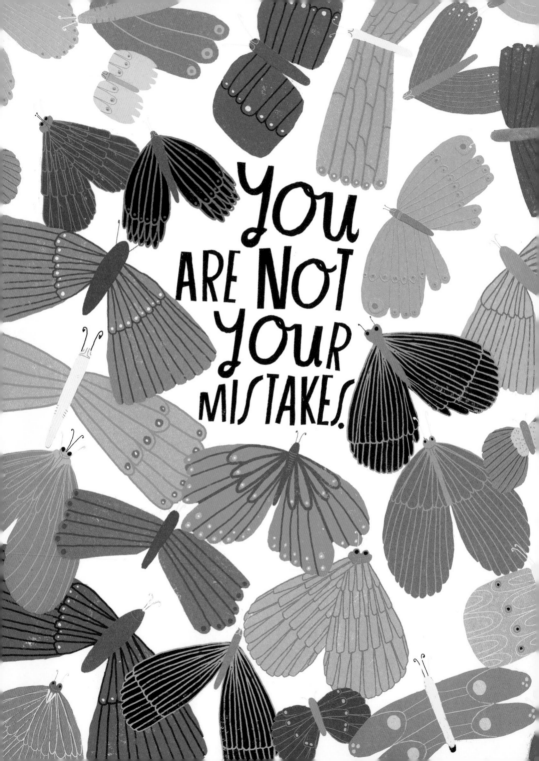

YOU ARE NOT YOUR MISTAKES

—

It's important to take responsibility for and learn from mistakes in order to grow. But no matter how you may have screwed up in the past, your mistakes do not define who you are. You are not your past habits. You are not your failures. You are not the accumulation of your embarrassing, shameful moments. You are a child of the universe, a whole human being, worthy of love, worthy of belonging, worthy of happiness, fulfillment, and light.

SUCCESS IS TO BE MEASURED NOT SO MUCH BY THE POSITION THAT ONE HAS REACHED IN LIFE AS BY THE OBSTACLES WHICH HE HAS OVERCOME WHILE TRYING TO SUCCEED. BOOKER T. WASHINGTON

OWN YOUR EXPERIENCE

—

Sometimes we walk through life under the illusion that we aren't enough — that our life experience is too boring, too uninterest-ing, too ridden with mistakes, or too shameful and that we don't deserve success or happiness. But what if we changed the story we told ourselves? What if we began to own the idea that all of our life experiences make us wiser, more enlightened, more compas-sionate, and more judicious, not less so? Owning and valuing your experience — no matter how unconventional — is some of the most important work we can do.

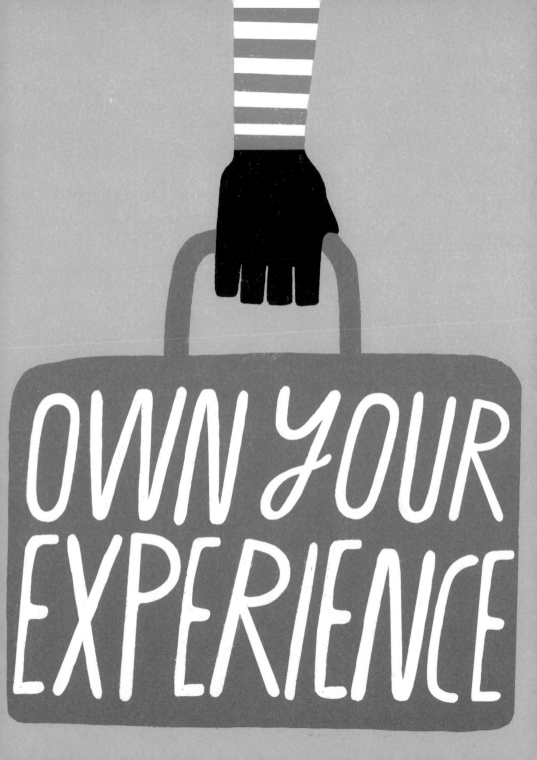

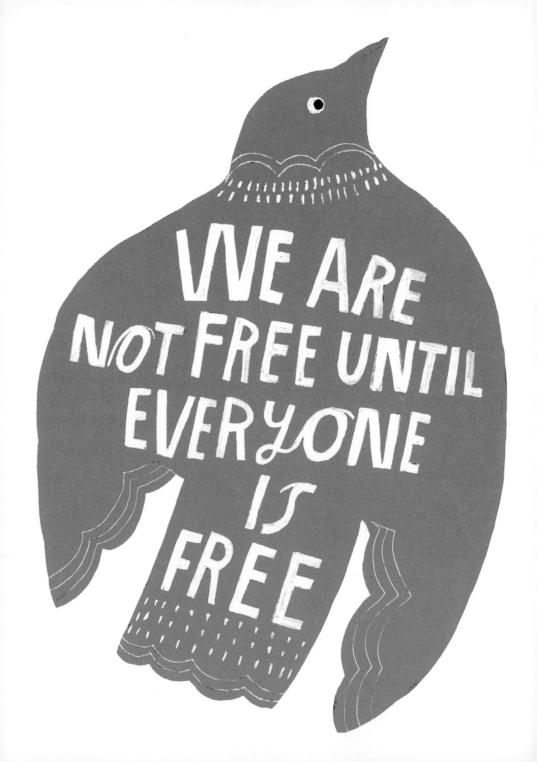

WE ARE NOT FREE
UNTIL EVERYONE IS FREE

—

May we all be committed to the struggle for a world where we are
all free of racism, sexism, homophobia, transphobia, gun violence,
poverty, inequality, hatred, marginalization, bullying, harassment,
and every single form of oppression that hurts us as a human race.
May we all use our privilege as a means to fight for social justice
and for an end to senseless violence and discrimination against
vulnerable people. Your voice matters. Your wallet matters. Your
vote matters. Use them.

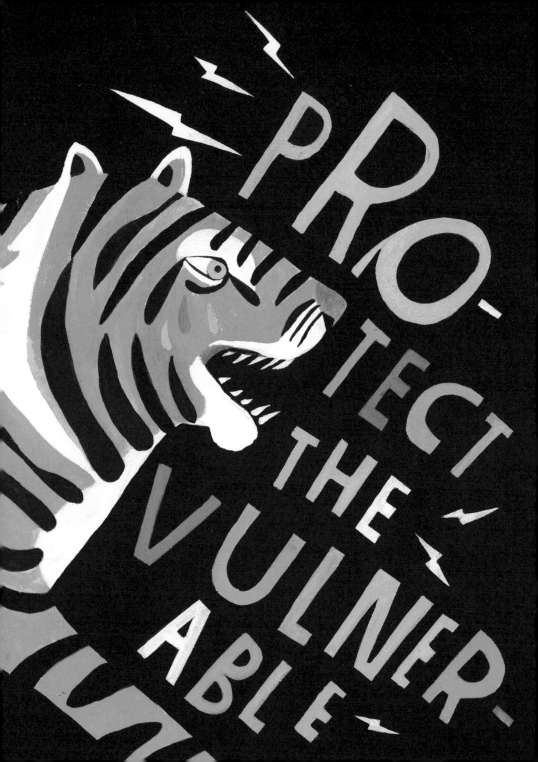

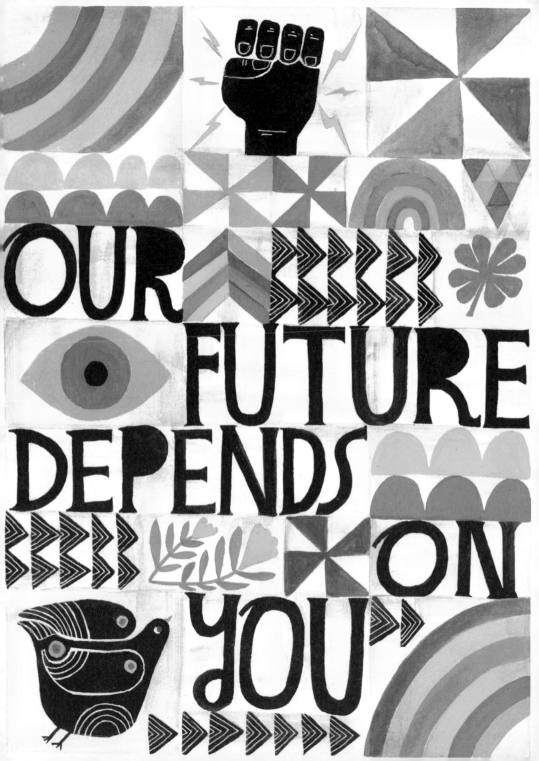

COMPLACENCY IS A PRIVILEGE

—

May we all be more conscious of our privileges and realize that in order for democracy — and all that it stands for — to prevail we must all be active participants in fighting for the rights of all people. From engaging in dialogue to writing and calling your law-makers to donating money to protesting, there are countless ways we can participate. Find ways to make a difference, even when an issue might not affect you directly. Be engaged!

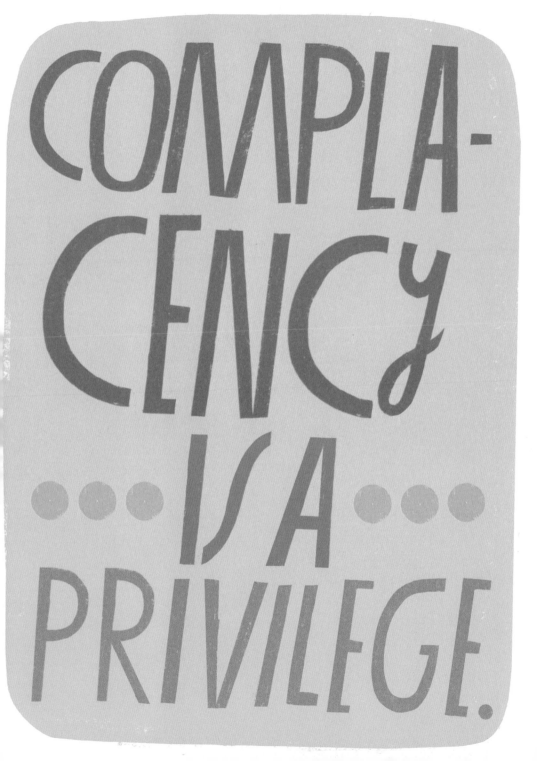

THE GOLDEN

BE FRIENDS

WORLD AND

THE WHOLE

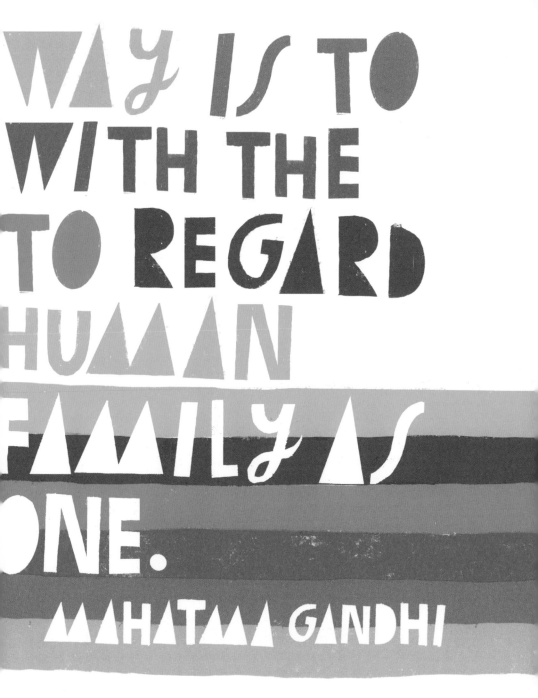

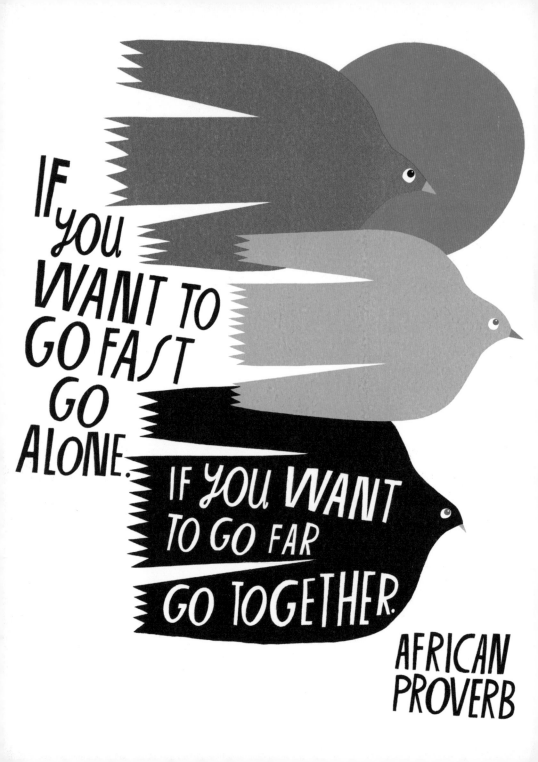

YOU ARE EXACTLY WHERE YOU NEED TO BE.

YOU ARE EXACTLY WHERE
YOU NEED TO BE

—

This phrase can be life-changing when you apply it to difficult situations. When we say to ourselves, "This isn't working out the way I wanted, and this is exactly where I need to be," it reminds us that everything that happens on our paths — even the confusing, scary, disappointing stuff — is an essential part of our path, there to teach us something or humble us in some way. It also reminds us that every person's path is different. Your path is yours. Hers is hers. His is his. Theirs is theirs. What we can control is how much openness we extend to ourselves on our paths, how much we allow ourselves to be vulnerable, fumble, fail, and risk with a sense of humor and affection. May we all do better at allowing the full range of our experiences — even the crappy experiences — to nurture us.

WE ARE WHAT WE
THINK. ALL THAT
WE ARE ARISES WITH
OUR THOUGHTS.
WITH OUR THOUGHTS,
WE MAKE THE
WORLD.

BUDDHA

PERMISSION TO TAKE AN INTERMISSION

—

Our culture loves the hustle. We sometimes make people who are not naturally inclined to hustle feel like there is something wrong with them. We reward hustlers with a badge of honor and prestige. Are you a "good hustler"? Is your identity caught up in being busy, working hard, and modeling productivity? The truth is, living that way isn't sustainable. Eventually, a life defined by productivity makes us miserable. Having a hyper-productive work ethic can cause us to become physically ill and chronically anxious. On the other hand, when we give ourselves permission to take regular rest, take on fewer projects, and have boundaries around hustling, our minds become clearer, our bodies more relaxed, and our lives less stressed. Saying no to stuff you don't have time for in favor of rest means you will occasionally disappoint other people. And that can feel hard sometimes. But it's worth it. It's not only okay to rest and move slowly when you need to, it's integral to your happiness and health.

PERMISSION TO TAKE AN INTERMISSION

WHEREVER YOU ARE, BE THERE TOTALLY

—

Given the fast pace and hectic schedules of our lives, we have grown used to living with anxiety, stress, and general unhappiness, as if all of those things are a necessary condition of life. Our tendency to ruminate over the past or trip on the future can leave us exhausted and drained. Sometimes just being in our own skin can feel uncomfortable. When we pay attention we realize that we spend a lot of time avoiding and distracting ourselves from uncomfortable feelings — like not knowing what's going to happen next, or whether someone is going to text us back, or feeling lonely or disconnected. But the antidote to anxiety and distraction is a conscious awareness and a commitment to staying in "the now." When we focus on our feelings and whatever is happening in the present moment, instead of distracting ourselves from them, we begin to eventually feel a sense of ease and calm. We can practice this habit intentionally through meditation, which strengthens our ability to be present in the rest of our days. And we can also practice it at any moment in the day when we feel ourselves tensing up with annoying thoughts or worry.

LOVE THE
AND THE
OF THAT
WILL SPREAD
ALL BOUND

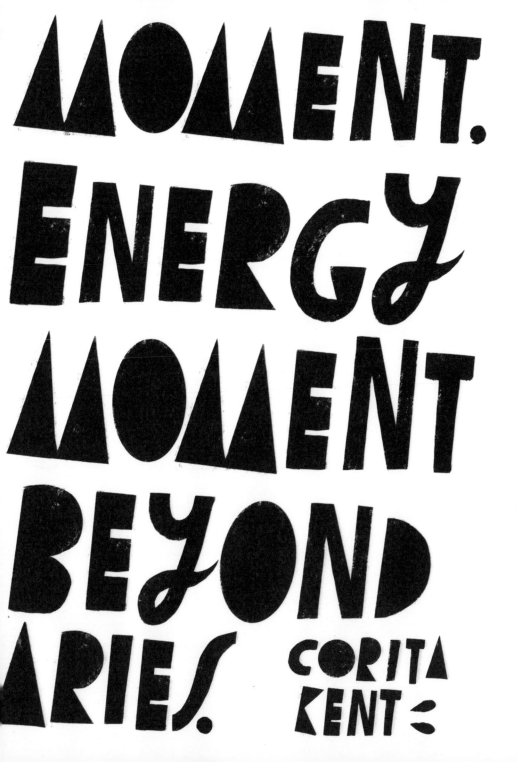

MOMENT, ENERGY MOMENT BEYOND ARIES.

CORITA KENT

OWN YOUR STORY

—

Has anyone ever said to you, "Thank you for sharing your story," after you shared something painful or a difficult experience? We appreciate it when people tell honest stories, because it isn't usually the easy, happy stuff that connects us. It's more often the painful, shameful, embarrassing stuff. Owning, honoring, and sharing your story — especially the uncomfortable parts — is lifelong work. But the payoff is tremendous, because vulnerability is necessary for true connection with others.

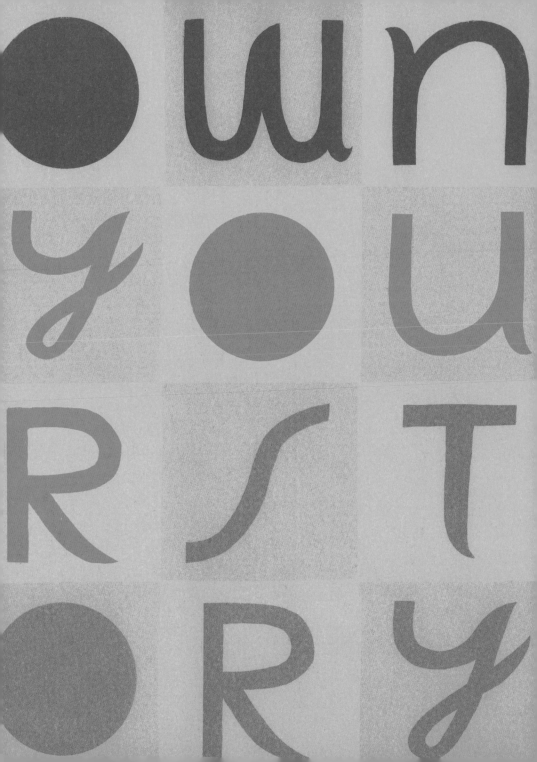

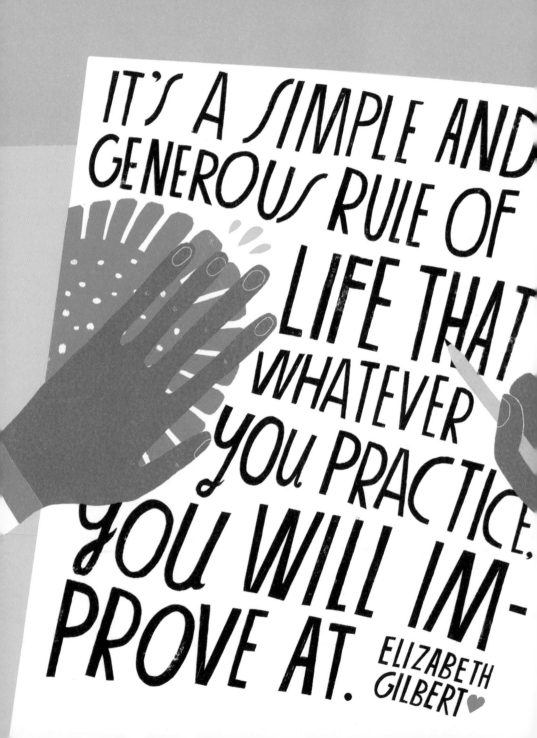

IT'S A SIMPLE AND GENEROUS RULE OF LIFE THAT WHATEVER YOU PRACTICE, YOU WILL IM- PROVE AT. ELIZABETH GILBERT ♥

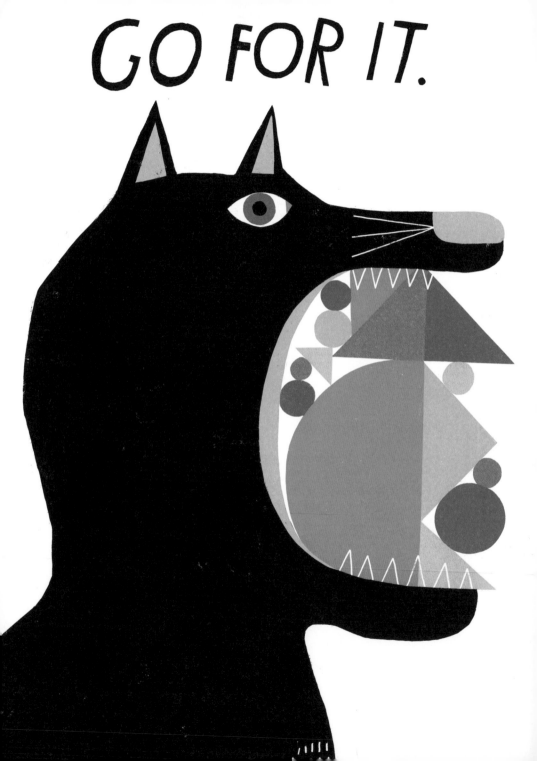

GO FOR IT

—

When you find yourself saying "that can't be done" or "I could never do that" or "that will never be successful," STOP! Allow yourself to open your mind to positive outcomes. While failure is most certainly an option, so is the fact that something might actually work. No experience is foolproof. If we sit around and wait for the perfect moment or perfect circumstances, we might be waiting forever. No great step in anyone's life happened without some amount of risk.

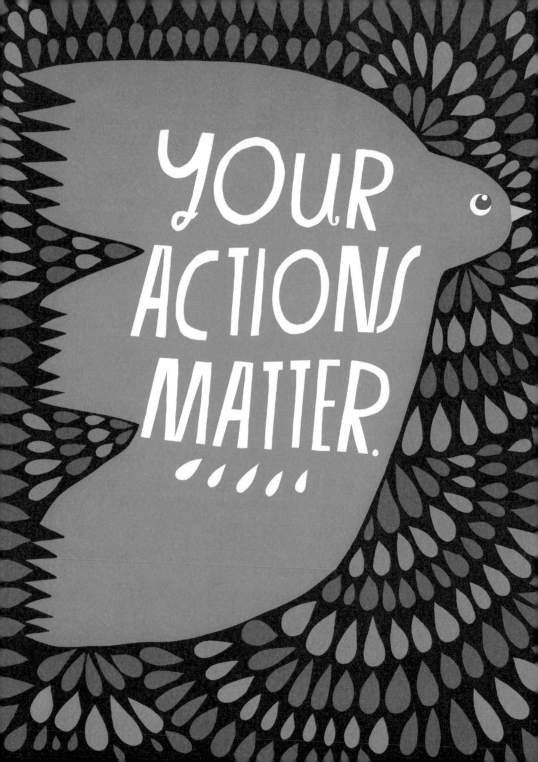

BEGIN ANYHOW

—

We have lots of ideas. Our minds are swarming with them. But getting from our ideas to action is sometimes a messy process. And knowing and fearing that (as we all do) overwhelms us. And so we sometimes wait for just the right moment to take action on our ideas. We are afraid if we start something before we're ready we'll be reminded that we are not good enough. We don't want to risk failing. We want to be comfortable. We want exactly the right skills, the right materials and supplies, the right knowledge, the perfect space in our busy schedule before we even begin something to minimize the chances that we'll feel bad. So we wait. Or we do nothing. Or we do "research" but never take any action. The problem is that there is no perfect moment to begin anything. Life is messy, no matter how hard we try to make it clean and smooth. I'm not knocking being prepared. Having some good tools, some basic skills, and a solid routine is awesome. But they do not prevent failures and challenges. The things we take pains to avoid are actually an essential part of life. The hard and uncomfortable stuff helps us learn and strengthens our grit. And if there is one thing I've learned, it is that inside the messiness is also almost always where the magic happens. So we have to take a deep breath, summon courage, and begin anyhow.

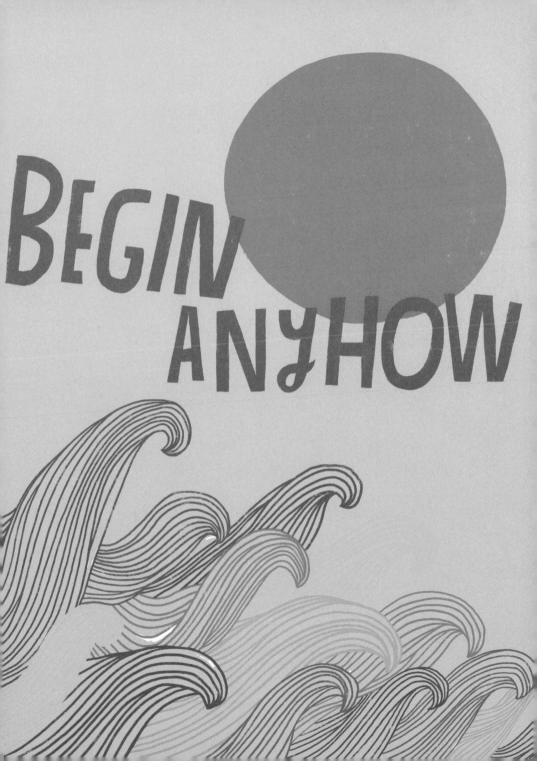

RESPONSIBILITY CREATES AGENCY

RESPONSIBILITY CREATES AGENCY

—

Sometimes in life, when things don't go the way we want or the way we think they should, we might feel like a victim: a victim of other people's cruelty or whims or disregard for us; a victim of bad circumstances; a victim of bad luck; a victim of being inherently unlovable, unworthy, or invisible. Feeling like a victim can leave us depressed and anxious. Feeling like a victim can also be a way to avoid taking responsibility for things that are not going well — including our relationships or work. When we begin to take responsibility for our choices and behavior, we begin to feel more agency and power to shape our lives differently. It can be painful to realize how much of our heartache we have created through our own identification with unworthiness or victimhood. But when we change our story from "I am a victim and I blame others" to "I take responsibility for my life," we experience more joy, more calm, and a greater sense of purpose. Taking responsibility for our choices is essential to growth, happiness, and transformation.

MAKE MAGIC HAPPEN

—

With effort, we can make magic happen. Contrary to what most people think, making magic requires discipline. You must exert effort to become a better artist, athlete, musician, writer, communicator, student, fill-in-the-blank. Some of the most incredible ideas never turned to magic because the person who had them never took action. But when you take action on your ideas and dreams, your efforts can lead to magic — stuff that transforms lives, disrupts the status quo, changes the conversation, shifts mind-sets, and offers comfort and connection to those who need it most. Don't wait around. Make magic happen.

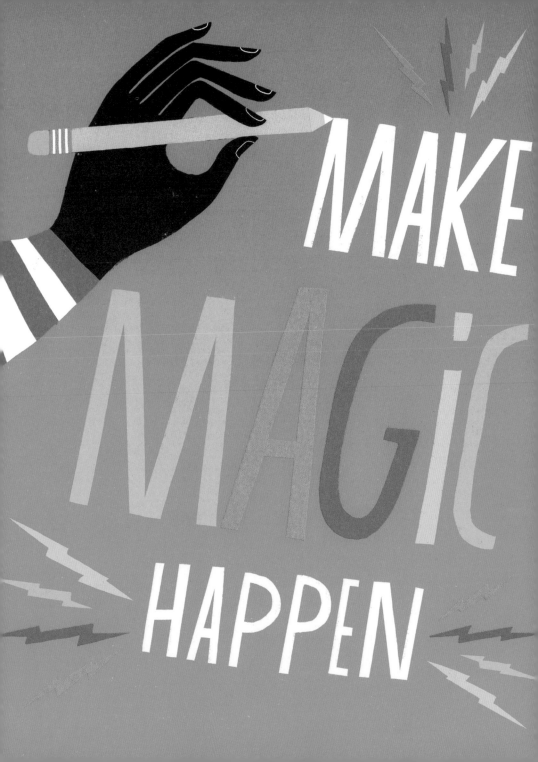

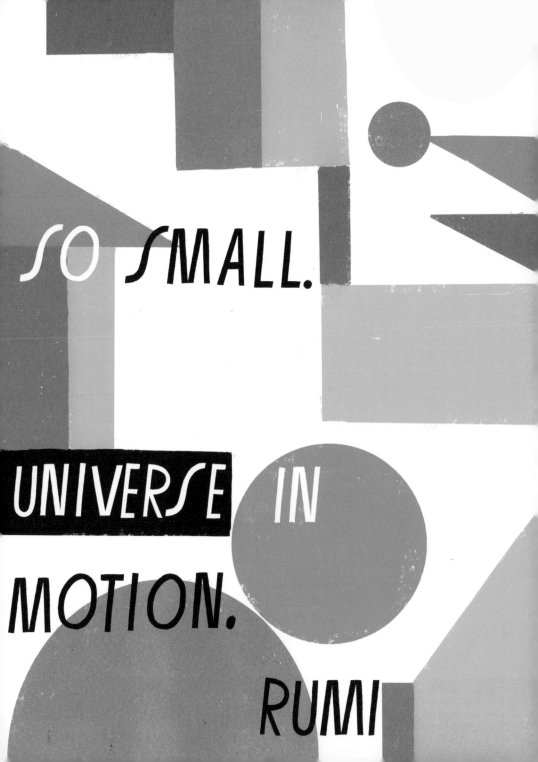

SO SMALL.
UNIVERSE IN
MOTION.
RUMI

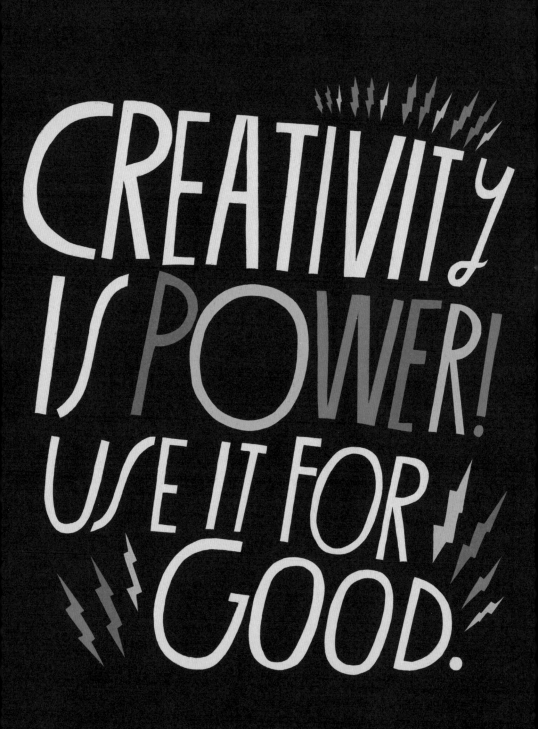

CREATIVITY IS POWER!
USE IT FOR GOOD

—

Everyone is creative! Even you! And there is power in your creativity — your ideas, how you innovate, how you think. Your creativity is a vehicle. It has energy. It can change the world for the better. Use it for good.

YOU ARE NOT ALONE

—

Whatever you are going through, someone else is going through something similar. Whatever challenges you face, others are facing them too, right at this very moment. Whenever you feel lost, know others are lost too. Whenever you feel alone, allow that knowledge to hold you. You are not alone.

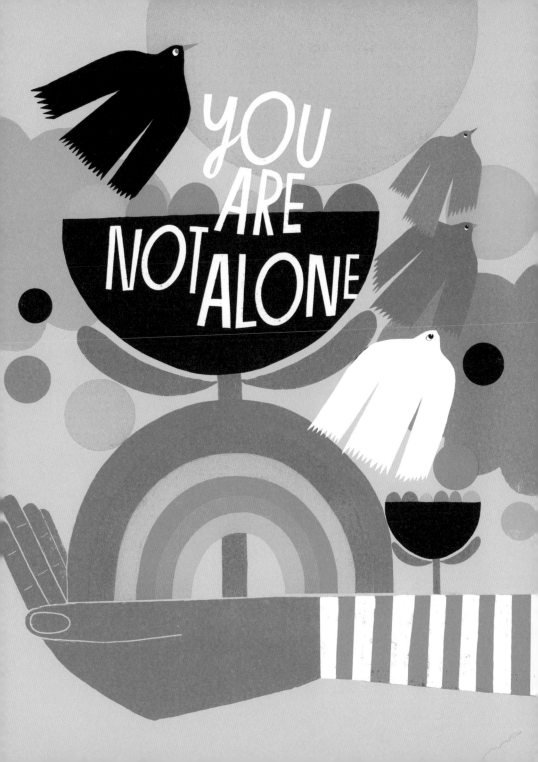

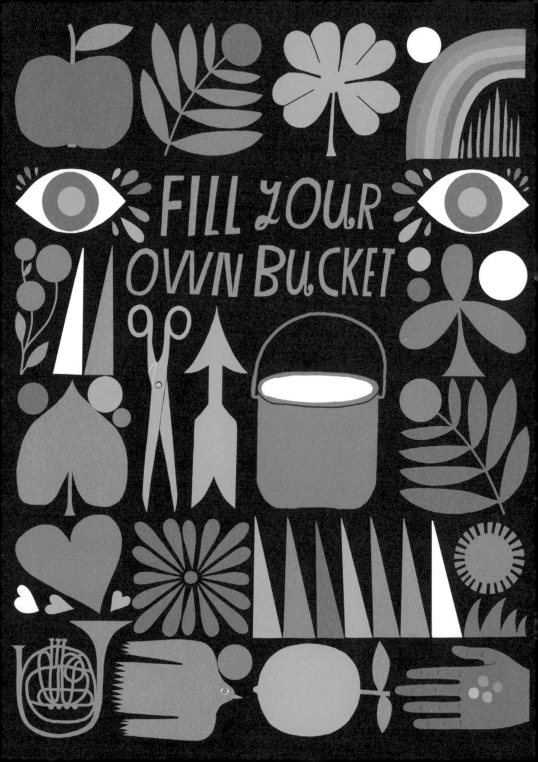

FILL YOUR OWN BUCKET

—

Think of your daily life as a bucket that is your responsibility to fill. When your bucket is full, you have a lot of energy and you feel good. We can fill our own bucket by taking care of our body, eating healthy food, getting enough rest, honoring boundaries, learning new things, engaging in creativity, spending time with people we love, doing work that we love, and living in alliance with our values. Sometimes we make the mistake of either trying to fill other people's buckets instead of our own or filling our buckets with unhealthy things, and our own bucket becomes depleted. When this happens, there is always a chance to go back to filling our own bucket instead. Paying attention to filling your own bucket is the first step.

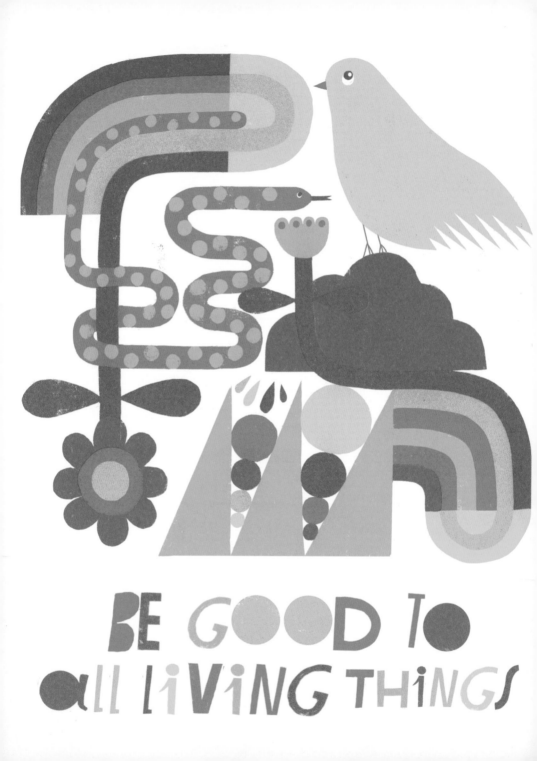

BE GOOD TO
all LiViNG THiNGS

all in.

MAKE YOUR OWN PATH

—

In the world today, we have so much more direct information about other people's lives than we've ever had before. Social media keeps us abreast of everyone's activities and accomplishments. As a result, we may sometimes feel like our lives aren't as interesting as other people's or that our work isn't as impactful or our bodies aren't as attractive. What we see on social media can make us feel horrible about ourselves! So it's important to use social media judiciously and to stay focused on the health and progress of your own journey without comparison. Create and nurture your own path.

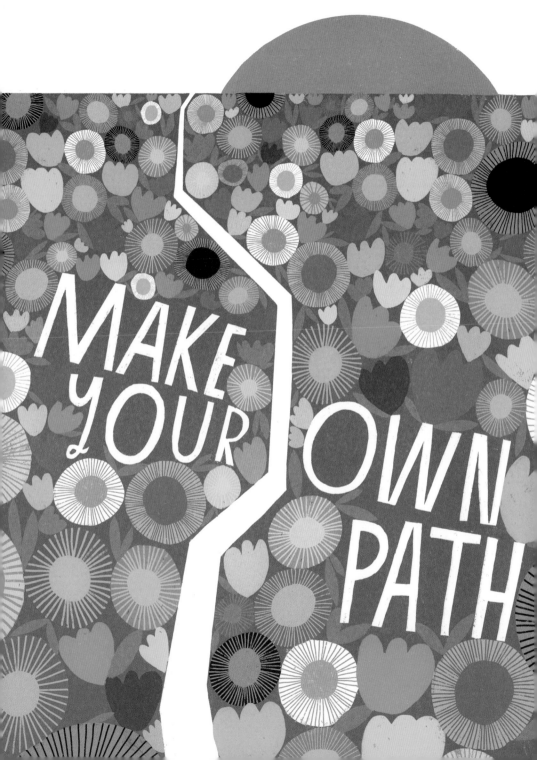

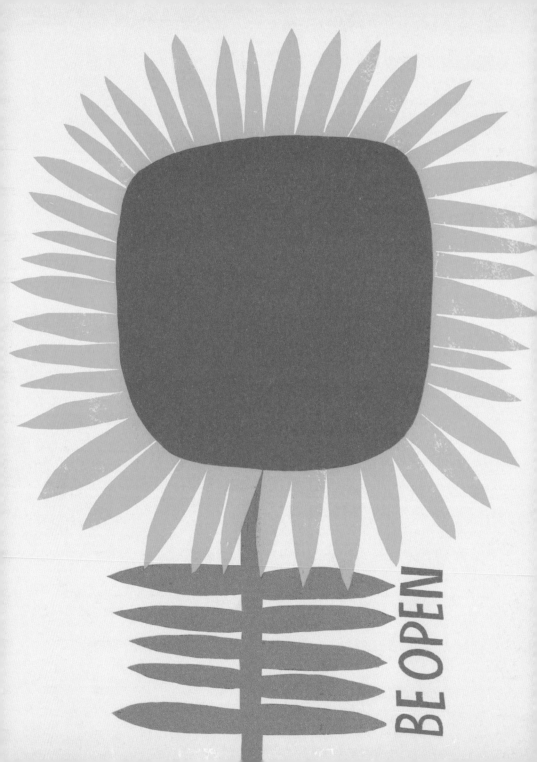

BE OPEN

—

When we are open to experiencing and engaging with life fully, and when we think in terms of possibility instead of what won't work, even in challenging circumstances, our capacity for growth and achievement is boundless. Have you had an intense emotional reaction to music or art? Have you tried something creatively even though you had no idea what you were doing or where it would lead? That was you being open! Even simple things like walking a new route with your dog each day or listening to a different genre of music can wake you up to new ideas, possibilities, and pathways.

FIND WHAT FEEDS YOU

—

Staying motivated to keep your continued sense of happiness requires its own form of discipline. It requires staying open and curious. It requires searching for and diving deep into what feeds you — and allowing yourself to head down dark rabbit holes. Sometimes what feeds you isn't cerebral at all, but is found in moving your body by walking, dancing, or athletics. What's important is to make space for the searching, and then to use what you find — at least the parts that excite you most — as the inspiration and energy for living your life. Want to stay inspired and motivated? Make space for it. Get enough rest. Be curious. Read books. Watch films. Listen to podcasts. Go look at art. Get out into the world. Go to therapy. Participate in a revolution. Uncover your own story. Find what feeds you.

OUR FEELINGS AREN'T THE PROBLEM. IT'S OUR RELATIONSHIP TO THEM.

AMBER RAE.

OUR FEELINGS AREN'T THE PROBLEM— IT'S OUR RELATIONSHIP TO THEM

—

We all have feelings. And a lot of the time, our feelings haunt us. They overwhelm us, they paralyze us, they cause us to say things we later regret. But what if we began to think about our feelings as a normal reaction to life's experiences? And what if instead of identifying them as good or bad, we changed our relationship to them and saw them as information for learning? What if we examined our feelings deeply and attempted to get underneath them to find out what we needed more of or less of? And then we acted on those learnings? Compassion toward ourselves and our feelings does not come easily. But when we are curious about how we are feeling (good or bad) and examine what the feelings are trying to tell us, they become valuable tools and important information instead of controlling forces.

GET COMFORTABLE
FEELING UNCOMFORTABLE

—

Nearly every day, at various moments, we feel uncomfortable. There is no way of avoiding it. Someone says something that makes us feel insecure. We have an awkward interaction with a friend. We fail to achieve something that feels important to us. When we feel discomfort, we naturally want to make it go away. Sometimes we do that by distracting ourselves with food or alcohol or scrolling through our phones. Sometimes we do that by putting on a smiling face, stuffing our feelings down, and pretending everything is okay. Sometimes we become defensive. But when we ignore discomfort, we ultimately only gain anxiety and obsessive thoughts and we lose out on learning and growth. Conversely, when we sit with the struggle, enter darkness, and get comfortable with feeling uncomfortable — and we ask, "Why am I feeling this way right now?" and "How can I work through it in a way that is kind and gentle to myself and others?" — we are able to see patterns in our behavior or choices that are holding us back or causing us pain. And when we see these patterns clearly instead of ignoring them, we have the opportunity to work on and change them. Get comfortable feeling uncomfortable. It's what leads us to the light.

YOU HAVE NOT GROWN OLD, AND IT IS NOT TOO LATE TO DIVE INTO YOUR INCREASING DEPTHS WHERE LIFE CALMLY GIVES OUT ITS OWN SECRET.

RAINER MARIA RILKE

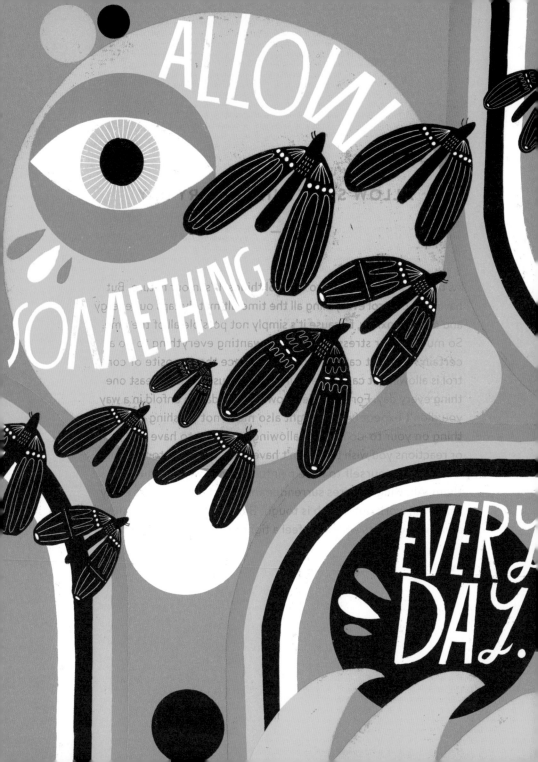

ALLOW SOMETHING EVERY DAY

—

As human beings, we like to control things. It's in our nature. But having to control everything all the time ultimately zaps our energy and causes anxiety, because it's simply not possible all of the time. So much of our stress is caused by wanting everything to go a certain way. That can be exhausting! Since the opposite of control is allowing, it can be helpful to consciously allow at least one thing every day. For example, allowing your day to unfold in a way you didn't expect (which might also mean not finishing everything on your to-do list). Or allowing someone to have feelings or reactions you wish they didn't have without having to fix them. Or allowing yourself to have painful feelings without burying them. Allowing requires surrender and a certain trust that everything will work out, which is tough. But when we consciously allow in moments where we feel a tight hold, peace settles in.

ALWAYS BE A BEGINNER

—

Did you know that studies show that approaching your work and life with the mind of a beginner — even the stuff you're technically an expert at — will increase your ability to learn, grow skills, and activate more creative thinking? It will also open you up to different perspectives and possibilities. Start with the openness of a beginner and watch your own creative thinking flow.

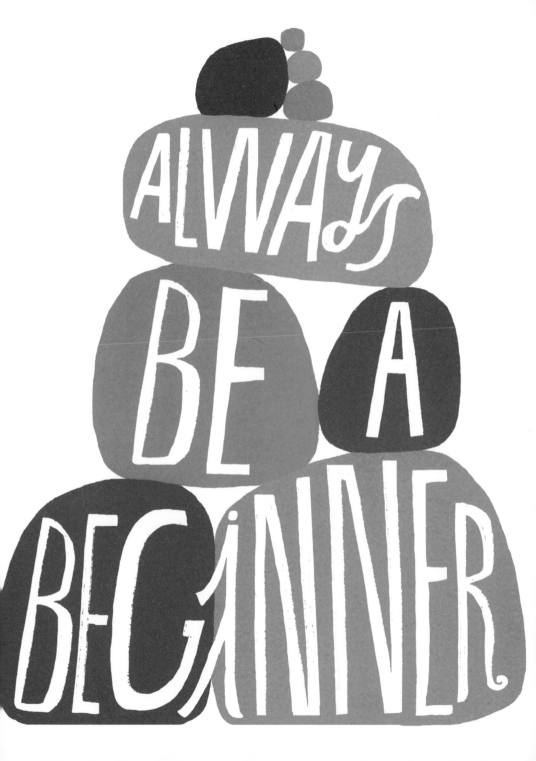

STANDING UP TO CULTIVATE MIND. ONE W THAT OUR VOI OUR IDEAS M

REQUiRES US
a State of
HERE WE BELiEVE
E MaTTERS, THaT
TTER. THaT WE
MaTTER.

TaNia
KaTaN

YOUR STORY MATTERS

—

One of the things that hinders people from being vulnerable or expressing themselves with others is this notion that they have nothing to say – that their story (their life experience, their background, their path) is either too shameful or too insignificant, boring, uninteresting, or irrelevant to matter. But the truth is every single person has a story worth sharing and celebrating, including you. Your story is what makes you human. In fact, no matter who you are or what has happened in your life, your struggles are usually the most compelling parts of your story. Sure, we are all imperfect beings, and yet we're all worthy of love and belonging. When you share your story, you model self-love and compassion for others. And, most importantly, true connection cannot happen without vulnerability. Don't hide or diminish your story. Allow it to be evidence of your great humanity, of learning, redemption, hope, and change. Your story matters.

NO ONE OWES YOU ANYTHING

—

We all find ourselves thinking, "Wait, that person owes me that!" And that's because some of us were conditioned to believe that we are owed things from others. For example, you might have done something nice for a friend, and so therefore he owes you something in return. Or you might think you have more education or status than other people, and therefore you deserve more respect or opportunity. This faulty, conditional perspective only causes disappointment and resentment. And that's because we cannot control how other people treat us or feel about us or respond to us. We are also not entitled to special treatment. We cannot make our happiness dependent on whether people repay our kindnesses or look up to us or see how much we love them. It just won't work. You alone are responsible for your own happiness and sense of completeness. Making it dependent on what others "owe" you will ultimately leave you feeling disappointed. Conversely, when you live your life by giving of yourself and using your talents freely and openly when it feels right to you (without setting up situations where you feel entitled to get something in return), you will find great peace and a sense of calm. We have everything we need inside ourselves already.

CHOOSE YOUR ATTITUDE

—

You cannot always choose what life puts in your path. But the good news is that you can always choose how you respond to it. Choosing things like learning, growth, self-love, empathy, and humor will always create greater ease while working through difficulty.

BE KIND; EVERY-ONE
YOU MEET IS
FIGHTING A
HARD BATTLE.
IAN McLAREN

ENOUGH IS A FEAST

—

What if every time we felt disappointed, or found ourselves wanting more or better or different, we stopped and told ourselves: I am enough or this is enough or I have enough? What if we followed that up with reminding ourselves about all the things we are grateful for in the present moment? When we let go of the need for more or better or different, we are free to see the riches we already have. And then everything actually does change. Enough is a feast.

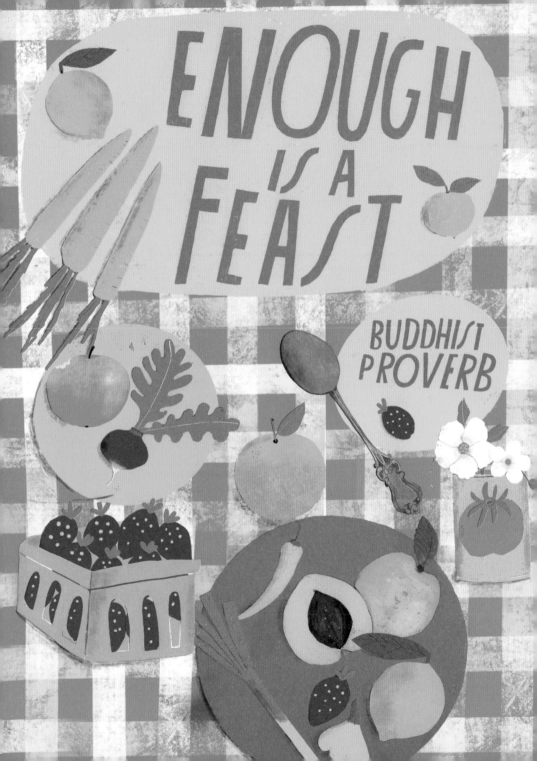

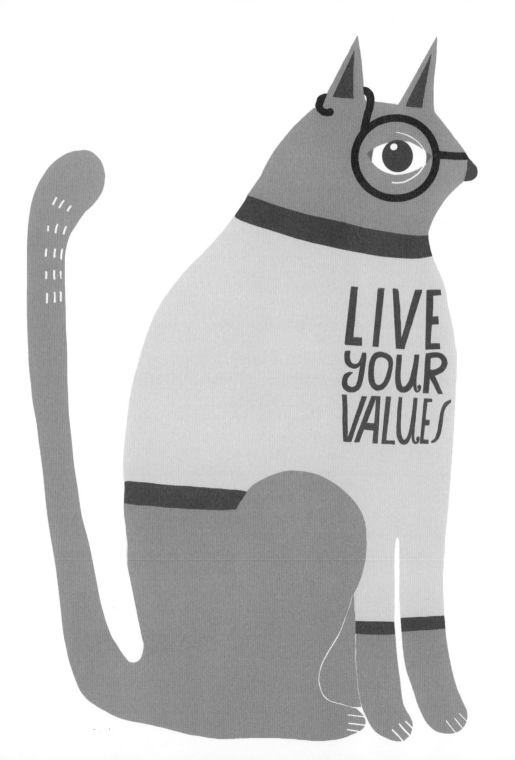

LIVE YOUR VALUES

—

Make a list of your top values. And then assess whether your life choices (relationships, work, habits, hobbies) are in alignment with your values. When we live in alignment with our values, we feel a greater sense of motivation and connection to our daily activities. Often, the disconnect you feel from your work, your friendships, and your hobbies may actually be a disconnect with your values — in other words, *what you value most* in your life. Examples of values include creativity, solitude, service, activism, loyalty, simplicity, and positivity. There are hundreds of examples of values. When you identify and narrow down to your core values — the things that are the most important to you — you can assess whether the choices you make in your everyday life are aligned with those core values.

WE
RISE
BY
LIFTING
OTHERS.

ROBERT
INGERSOLL

CREDITS

"People who make you chase them and leave you feeling uncertain are not your people." —Emily McDowell. © 2018. Used with permission from the author.

"When you can't find someone to follow, you have to find a way to lead by example." —Roxane Gay. From *Bad Feminist: Essays*, Harper Perennial, © 2014. Used with permission from the author.

"We are not free until everyone is free," inspired by the quote by civil rights activist Fannie Lou Hamer, "Nobody's free until everybody's free."

"Love the moment and the energy of that moment will spread beyond all boundaries." —Corita Kent. © 2020 Estate of Corita Kent/Immaculate Heart Community/Licensed by Artists Rights Society (ARS), New York.

"It's a simple and generous rule of life that whatever you practice, you will improve at." —Elizabeth Gilbert. From *Big Magic*, Riverhead Books, © 2016. Used with permission from the author.

"Our feelings aren't the problem. It's our relationship to them." —Amber Rae. From *Choose Wonder over Worry*, St. Martin's Essentials, © 2018. Used with permission from the author.

"Standing up requires us to cultivate a state of mind. One where we believe that our voice matters. That our ideas matter. That we matter." —Tania Katan. From *Creative Trespassing*, Random House, © 2019. Used with permission from the author.

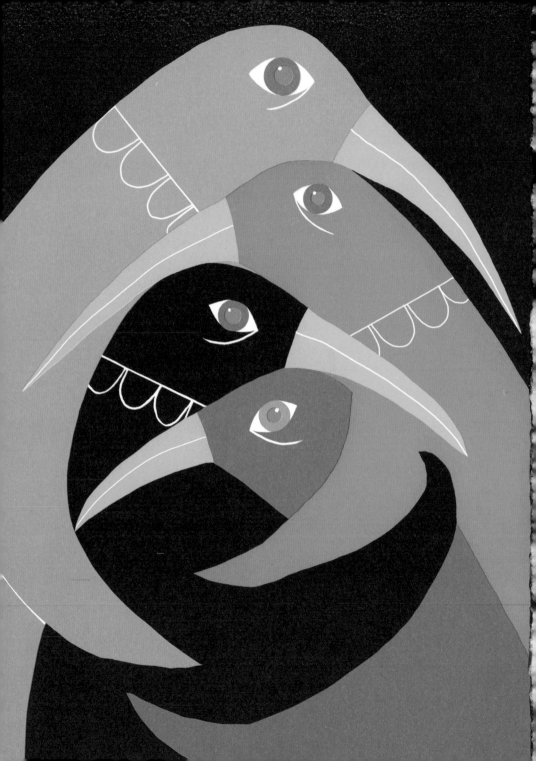